Jeanne Guyon

Nobody Knows

The

Jeanne Guyon

Nobody Knows

Gene Edwards

Edwards, Gene
The Jeanne Guyon Nobody Knows / Gene Edwards

ISBN 978-0-9778033-3-0

Printed in the United States of America

SeedSowers
Christian Books Publishing House
PO Box 3317
Jacksonville, FL 32206
(800) 228-2665
www.SeedSowers.com

In Memoriam

Ruth Graham

On the evening I first met her and her famous husband, as only a young man can, I asked her about an issue with which Helen and I were dealing. Helen and I were both called of God, but our callings were quite different. It turned out that she and Billy had faced the same issue during their courtship.

She was the most down-to-earth, practical Christian lady I had ever met. Her words of wisdom were invaluable. I later had the privilege of having a close friendship with her father, the inimitable John Nelson Bell. He even added my name to his famous daily prayer list. She, in turn, later consented to write the introduction to Jeanne Guyon's autobiography.

Having come to know her so well, I can tell the world there are two men who married well.

There could be no other person to whom I could dedicate this book. It is with the deepest, most profound gratitude that I dedicate this book to the much-beloved Ruth Graham.

A WORD OF THANKS

to
Jennifer Jeffries
for the illustrations in this book.

While I was in Europe doing research on the story of the nonconformists of church history, I had to decide whether Jeanne Guyon should be numbered among that special company of believers. The obvious answer would be no: After all, nonconformists are believers who refuse to be either Protestant or Catholic (and are very radical about the waywardness of both). Their opposition, of course, usually meant the loss of their lives.

Jeanne Guyon was a devout Roman Catholic; yet, on the other hand, she fits no one's list! Though Guyon was a devout Roman Catholic, she nonetheless singlehandedly caused one of the greatest upheavals in the history of Catholics, Protestants, *and* the Nonconformists. Her life broke all established norms.

It bears noting that the greatest names of women who did not conform to their age, Joan of Arc and Jeanne Guyon, were both French.

As a writer who is, and as one still being read today, Jeanne Guyon is the best-known woman author in European history. To become what she was is close to impossible. That is, Jeanne Guyon lived in an age when even the thought of a *woman* making history (and headlines) all over Europe could not have been imagined.

A few things to note: Jeanne Guyon is the only woman ever to do a commentary on the Bible. She is the only woman I know of whose books were publicly burned. Her autobiography and biography remain the most read of any Christian woman. After three hundred years, she outsells any writer of the 1600s, with the exception of Shakespeare.

If a Christian is looking to read a book on the life of a devout believer—one who suffered and triumphed over all odds, the name Jeanne Guyon will come up first.

If you ask evangelical heroes who most affected their lives, the person most usually named is Jeanne Guyon. Hudson Taylor, George Fox, the Quakers, Watchman Nee, the Little Flock, and John Wesley would be among those names.

Guyon was imprisoned for a total of almost ten years in Europe's most infamous prisons. Yet, while there, she

was the most discussed woman in all Europe, making it look more like fiction than fact. The staying power of this woman's life and books, plus her influence on us until this hour, is unprecedented.

Jeanne Guyon, therefore, stayed on my list of nonconformists. That led me to make a journey into Jeanne Guyon's life. What a journey it was! The surprises never ended. Even after her death, there was the most amazing surprise of all.

I began by traveling to her hometown of Montargis. The first of many surprises came when I came to the Hotel de Ville (the county courthouse), there to find her name engraved on its front.

Jeanne grew up in a family of French royalty. She has written in detail of her early life. While still a child, she received an invitation from the English Crown to come to the English court and live in the palace of Queen Elizabeth. Her parents declined the invitation. At the age of fifteen, her father arranged her marriage (February 18, 1664) to a man who was in his late thirties, twice her age.

After her marriage, she lived on a street which, translated into English, means *God's Oven*. I have always felt that if

3

Hotel de Ville — Jeanne Guyon's name is engraved on the front of the courthouse in her hometown of Montargis.

someone were to write a new biography of Jeanne's life, that book should be entitled *God's Oven.* After all, it was on this street that Jeanne, at such an early age, suffered so much cruelty at the hands of her mother-in-law. After that point, her entire life was lived in . . . God's oven.

Out of that suffering grew a unique relationship with the Lord. It was one of coming to Him in a state of stillness. Her walk with the Lord Jesus was real. So also it was a life lived at the hands of the most famous and cruel names in all of French history.

I do not understand how anything as precious as coming to Christ and abiding in His presence for a few moments could cause anything as tempestuous as it did . . . and *still* does! One of the most serious charges laid against Jeanne was that she approached the Lord in such a quiet and personal manner. We can only conclude that the religious world believes you should come into the presence of the Lord with a mind racing at full speed.

The town of Montargis has been called the *Venice of France.* The town has narrow canals crisscrossing it from every direction. Such was the location of the home of Jeanne's husband. The house backed up to just such a canal, one far too narrow for a gondola of Venice.

Rue du Dévidet — The childhood home of Jeanne Guyon

I was allowed, eventually, reluctantly, to enter the house on the street of God's Oven. The French people guard their privacy. A perfect stranger asking to come inside someone's home is incomprehensible, but the family who lived there did allow me to go in.

Should you visit Montargis, find the Catholic Church where she took mass. Enter the building, go all the way to the front, and look to the right. You will see an engraving in the first alcove with the Guyon family name, indicating her family paid for that area of the church.

It happened that Jeanne's home actually had a Bible. A Bible in *any* home was extraordinarily rare.

Jeanne was born in 1648. Her maiden name was de la Mothe. As to her education, at age seven Jeanne had been placed in an Ursuline convent (an order of nuns that originated in Italy). Today the convent is a secular hospital.

Later Jeanne's father stopped her from becoming a nun, explaining that he wanted a life for Jeanne other than that of a nun. This was not typical Roman Catholic thinking of that day: A family expected at least one girl in the home to be a nun.

Rue du Four-Dieu (Street of God's Oven) where Guyon lived upon marrying

Her next education took place in a local Dominican monastery. Jeanne had the equivalent of a high school education; yet, the word *genius* would not be challenged by those who know her life.

After her marriage, Jeanne's mother-in-law constantly watched her to make sure she did not waste time in praying. Jeanne learned to pray silently. Doing so would one day impact France. Silent praying by a woman, or anyone for that matter? No prayer book? A long time spent in prayer was unique, except for some priests and nuns. This fact is one ingredient which later sent her to prison.

From the time Jeanne moved to her husband's home at 22 rue Four le Dieu (God's Oven), her life was in turmoil. Until Jeanne heard one sentence which changed her life. That word came from a Franciscan monk named Archange Enguerrand, who was Jeanne's first spiritual mentor: "Madame, you are seeking without what can only be found within." [1]

It was Jeanne Guyon who gave us a glimpse of having a living relationship with an indwelling Lord. Her words were among the first ever heard by evangelicals concerning the deeper things of Christ. Those who read the story of Jeanne Guyon's life will almost certainly run across the treasured

[1]There is another version of this story: While she lived in Paris, a monk, a perfect stranger, came to her and spoke those words to her.

Rue Raymond-Tellier — the water street behind rue du Four-Dieu, her marriage home

little book once entitled *A Short and Simple Method of Prayer*[2] where she frequently refers to a Lord who lives in us.

THE DEATH OF HER HUSBAND

Two of Jeanne's six children died of smallpox. She herself contracted smallpox and was disfigured as a result.

Under the tyranny of her mother-in-law, yet growing in her devotion to Christ, in July of 1672 Jeanne slipped into a closet and placed a ring on her finger, symbolizing her marriage to Jesus.

Jeanne's husband died in 1676[3]. At that time, Jeanne was almost thirty years of age. She found herself under enormous pressure to give her entire estate to the Roman Catholic Church. Had she done so, the money would have actually fallen into the hands of a local priest who would have been the true recipient of her wealth.

Jeanne refused to sign over her property. In so doing, she made an almost unique decision to supervise her own estate! Women simply did not do that. Jeanne did exactly

[2]Known today in English as Experiencing the Depths of Jesus Christ, SeedSowers Publishing House
[3]One hundred years before the American Revolution

Place Mirabeau – The church Guyon's family attended

that and did so for the remainder of her life. Further, she was *very* good at it. Again, women were not seen as being capable of supervising their own lives and their own wealth. Jeanne, however, was a very good businesswoman.

Here is a glimpse into the life of her uniqueness in endless numbers of areas. What she did, the way she lived, flew in the face of all the conventions of her day. Jeanne was one of Europe's earliest feminists! This became a two-edged sword. Her nonconformity was one of the reasons her enemies later called her a witch.

While I was in Montargis, I discovered that a new book had just then been published in French on the life of Jeanne Guyon. The author of that book, who happened to be the leading feminist in France, focused on Guyon as one of the earliest women to challenge the precedents of her day. This is one of the frequent evidences I discovered of Jeanne Guyon's influence stubbornly refusing to die.

In 1680 Jeanne came to be influenced by her spiritual director, a Barnabite monk named LaCombe. After having received much help from LaCombe, Jeanne once more did something that was unprecedented in her day. Jeanne began to travel with LaCombe, moving from place to place in France and Switzerland, teaching what later came to be

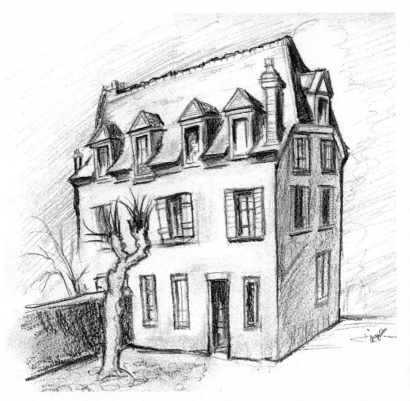

Couvente des Dominicaines – where Guyon received secondary education

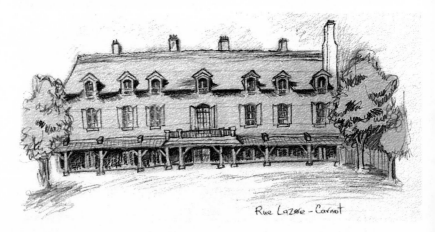

Rue Lazare-Carnot – an old building of one of the schools Guyon attended in Montargis

called *the interior way*. Later, when Jeanne became well-known and controversial, her relationship with LaCombe was exploited as a chance to claim she was immoral. Such is the fate of many nonconformists.

THE HOUSE OF THE VISITATION

Now we come to the first time in her life that Jeanne experienced being in serious trouble. Once again, it had to do with money. Her half-brother, a Roman priest, placed false charges against her in order to gain her estate. She was arrested and taken to one of the largest convents in France, the House of the Visitation. Who was responsible for her release? The very nuns who lived in the House of the Visitation petitioned for her release. Her life and her devotion to God set her free.

Then began her life as a writer. Jeanne Guyon is the most prolific Christian writer in church history. Keep in mind that she wrote everything by hand with a feathered quill.

Somewhere between 1680 and 1685, she wrote *A Short and Simple Method of Prayer*. The volume of her writings was staggering. Further, she was published and read. (This little lady had something to say, and she was determined to be heard.)

The House of the Visitation near downtown Paris. This church also had a vast convent. It is the first place of Guyon's four imprisonments.

Trouble would soon follow. It was because of that little book on prayer. That book implied it was possible for a Christian to have a private prayer life apart from the supervision of the church, without priestly guidance. This was outside of their doctrine and teaching. Furthermore, the church taught only one way of prayer. It was called contemplation and meditation. (The guts of this teaching are not Christian, but are based on the teaching of Plato.) If Jeanne had not later become so controversial, her book and its intent would have never been noticed. Just how controversial would she become? It went all the way to Rome, the issue landing on the pope's desk.

At this time, the wife of Louis XIV became aware of Jeanne's writings. It is ironic that while today the name of Madame de Maintenon is virtually forgotten, she was at that time the most powerful woman in France. Madame de Maintenon invited Jeanne to teach in the School of St. Cyr. This was a school which had been created by Louis XIV and Madame de Maintenon to educate the daughters of poor noblemen.

About this same time, there was a storm in Rome. A friend of the pope, a man named Michael Molinos[4], had a great following in Rome. Molinos was offering a practice of being with the Lord which came to be called Quietism.

Molinos, a Spaniard, lived in the Vatican in Rome. The pope was his closest friend . . . but not for long. The order

of the Jesuits became jealous of Molinos. He was not only arrested, but tried, convicted, and sealed in a dungeon.

Take note: There is no known connection between Guyon and Molinos. The only thing they ever had in common was that they both ended up in dungeons, one in Rome, the other in Paris.

The scene now adds more figures and more intrigue. So far we have Maintenon, Guyon, and Molinos. Add to that Fenelon. Fenelon was a cousin of Jeanne Guyon. He was a priest of great piety and was known and loved throughout France. He was influenced by Guyon's writings and then by their correspondence. Fenelon became the tutor of the grandson of Louis XIV. Maintenon, Guyon, and Fenelon dreamed of this child's having a possible reign as a devout Christian ruler of France.

Then there is Bossuet, the best-known archbishop in France. He was arrogant, egotistical, ambitious, and an orator of the first order. Bossuet was archbishop of the diocese of Meaux, with the hope of being archbishop of Paris and dreams of being a cardinal. He was called the Martin Luther of the Catholic Church because of his attacks

[4]Michael Molinos, *The Spiritual Guide*, SeedSowers Publishing House

on Protestant teachings. He also ordained Fenelon as an archbishop. All of these illustrious names were people who knew Jeanne Guyon personally.

Madame Maintenon had not only made Guyon the spiritual director of the young women who lived in the School of St. Cyr, but now she invited Guyon to come live in the Palace of Versailles.

JEANNE IN THE PALACE OF VERSAILLES

With all this in view, I decided to go to Versailles to see if anyone remembered Guyon's having lived there or if she had been forgotten. My surprise was immediate. I had underestimated Jeanne's influence[5]. After arriving at the palace, I randomly asked one of the guides if they knew anything about Jeanne Guyon and her time in Versailles. Instantly, the guide responded, "Oh yes," and pointed up. "Looking at the ceiling." Far above me, on the high vaulted ceiling, were paintings of hovering angels. The angels were depicted as waiting quietly in the presence of God. Guyon's influence at Versailles is woven into the history of that palace.

[5] In Will Durant's Story of Civilization, in the eleventh volume entitled The Age of Louis XIV, her influence on France is recorded.

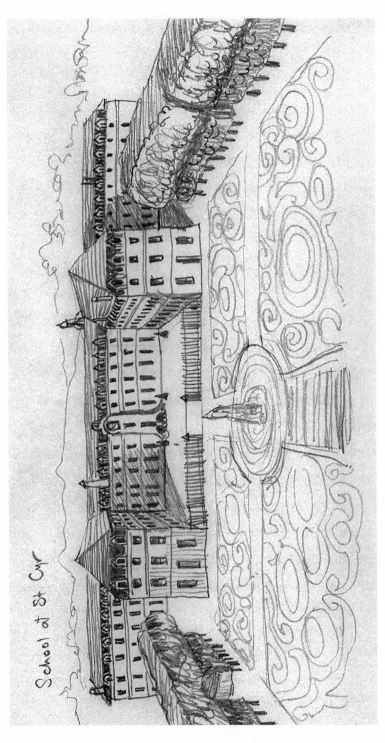

School of St. Cyr, which Guyon directed for a short time

Madame Maintenon, with her inordinate ego and seeing herself as growing spiritually, was becoming anxious to be seen as a devout woman. She approached Fenelon, asking if it would not be appropriate for her to take several steps toward leading and teaching spiritual matters. She was using words she did not understand and speaking of things she had never touched.

Alas, Fenelon both wisely and foolishly made it clear to Maintenon that she was a willful, blind hypocrite. Maintenon also spoke to Guyon, who gave a similar assessment.

Poor Jeanne! She never seemed to understand the depth of the depravity of the human heart. The frank words of Fenelon and Guyon to Madame Maintenon sent her into a rage. Blind with vengeance, she ordered Jeanne out of St. Cyr. Louis XIV, hearing negatives about Jeanne, rushed out of the palace, mounted a carriage, and ordered a complete change in the school. Madame Maintenon turned to Archbishop Bossuet.

Bossuet was utterly tied to Madame de Maintenon. Seeing her displeasure with Fenelon and Guyon, Bossuet had to condemn Guyon on any level he could find. He found that charge in the storm that was taking place in Rome. Bossuet charged Guyon with being a follower of Molinos and of being a Quietist, which had just been ruled heresy. So

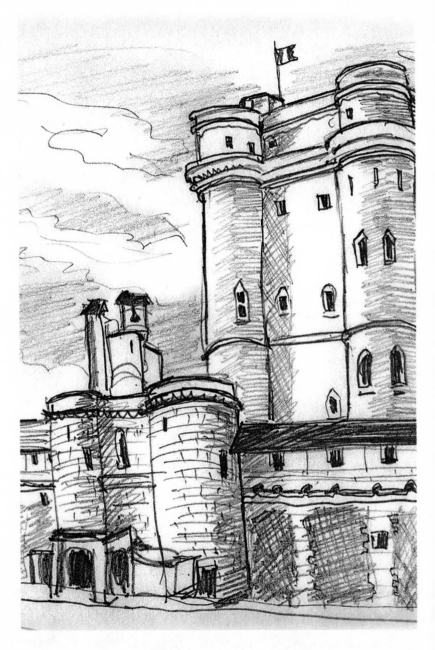

Vincennes Prison, the place of Guyon's second imprisonment

came the interrogation of Jeanne by three noted theologians there in the city of Meaux. Jeanne soon on "trial".

I decided to go to Meaux and visit the Bossuet mansion. His home and church were still there three hundred years later, except virtually the entire building was now a public library. I discovered something about today's France. When you visit historical sites which were once churches, there is no church there today. Instead, there is either a school or a library. The room where Bossuet is buried was all that was left of the church and his legacy. On one wall was a very typical painting of that day: Bossuet was surrounded by lightning and hovering angels, his face aglow. Even in this flattering portrait, Bossuet was extremely rotund.

Bossuet had a problem. He had just recently made Fenelon an archbishop. Attacking Fenelon now could be embarrassing. He did not do it, not at first. Yet, eventually Bossuet did attack Fenelon. What ensued would be remembered as the battle of the Titans. One day Fenelon would rise to the defense of Jeanne, while Bossuet did everything in his power to brand Jeanne a heretic . . . at least, . . . with threats of being burned as a witch.

As to the three-man tribunal, their interrogation came to be called *The Conference of Issy*. Today the place where the conference was held is a public school.

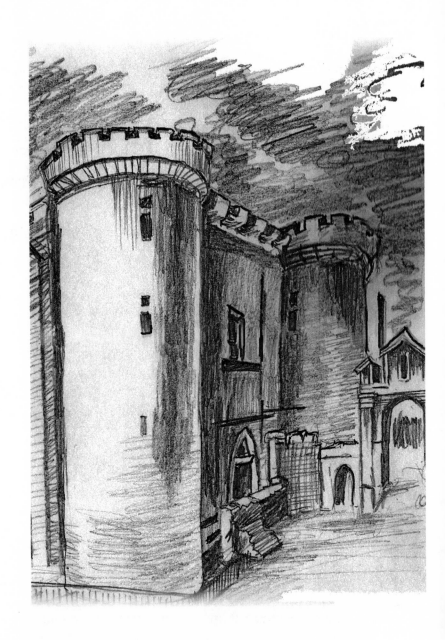

The Bastille, the place of Guyon's third imprisonment.

I could not help but think of Joan of Arc when I heard the story of the Conference of Issy. Joan, an illiterate eighteen-year-old peasant girl, was brought before the most learned men of her age, who threw theological terms and questions at her. Joan trounced them all. The records of that trial still exist. Joan of Arc's wisdom and replies were recorded. They were astounding. So also were the answers Jeanne Guyon gave at her trial before Bossuet.

Some of Jeanne Guyon's "trial" has also been left to us. The inquiry was supposed to be an informal hearing, but Bossuet did everything in his power to make it look like a trial *and* to paint Jeanne a heretic.

The conference ended without any clear conclusion. After the hearing, Jeanne was allowed to return home, or so she thought. Bossuet, hearing that she had departed his diocese, branded her a fugitive and a criminal. Jeanne went into hiding. (She was offered passage to Protestant England, but she refused.)

Was Jeanne a criminal? Or, was she free? Had she been declared a heretic, or something a little less than a heretic? Had Bossuet deliberately allowed Jeanne to leave his diocese so that he could charge her with fleeing justice?

At that appropriate moment, the archbishop of the Paris diocese died. Bossuet, looking for an opportunity to be seen as the only possible selection to fill this position, went to the king and asked him to brand Jeanne an escaped criminal.

Louis XIV settled the matter. She was to be found, placed in prison, and stripped of all rights.

Where did Jeanne hide? Somewhere in Paris! She had hidden in a place which has since been completely torn down, but you have heard of the location. The building was torn down to make room for a wing of the Louvre.

Where was Jeanne imprisoned? She was first placed in prison in Vincennes. Jeanne noted that Vincennes was far worse than the Bastille. She was actually grateful for later being transferred to the Bastille.

Today you cannot visit the Bastille because it was torn down at the outset of the French Revolution. Most people do not realize that you can visit a place virtually identical to the Bastille. Vincennes is a small version of the Bastille. Vincennes was once located outside the city of Paris, though today it is inside the city. Vincennes was built specifically for housing heretics!

I toured Vincennes. On my way there, I could not help but wonder if anyone was even aware that Jeanne had ever

been imprisoned there. (Again, I underestimated Jeanne's place in the lives of the French.) The opposite turned out to be true. The main reason tourists come there to the tower is to see the room where Jeanne was confined. In fact, Jeanne is the reason the tower has never been torn down. That day I felt I had actually visited the Bastille. Wonder of wonders . . . the most famous person ever imprisoned in Vincennes and the Bastille is *Jeanne Guyon*. The guide allows you to visit her cell and even close the door!

Jeanne was in Vincennes for a little less than a year. She was constantly interrogated and then given confessions to sign, which she refused. She had no friends. To be a friend to Jeanne Guyon was trouble enough for any soul.

This is one of the remarkable things about Jeanne Guyon: She attempted to be utterly indifferent to her surroundings. Jeanne lived what she taught. Throughout her next nine-plus years, she spent her time sitting in her Lord's presence. This was God's order throughout most of Jeanne's life. Her life story staggers the mind of almost every person who has read her life. If we are honest, we cannot say that we could adapt to such circumstances in so divine a manner. One of her poems reflected her capacity to live above her circumstances:

"I am a little bird placed in a cage by my God."

Vaugirard Abbey was Guyon's fourth and worst imprisonment. It was the worst prison in France

It was at the time she was transferred to the Bastille, she commented that the accommodations at the Bastille were far better than those at Vincennes.

For years Jeanne was confined to a dark cell with a small crack for a window, a cell freezing in the winter and broiling hot in the summer. Then there were her unpleasant visitors. Just about every well-known clergyman in France, dressed in their finest clerical robes, burst into her cell demanding that she sign a document confessing to false charges. Once, she was told she could immediately go free if only she would "sign this paper." Jeanne was certain about two things and would not be moved. One was that she was guilty of nothing. The second was that she would not confess to something which was not true. Her response to the offer of freedom if she signed: "The Bastille is not a negative thing in my life. It fits my nature and affords me time to be with my Lord."

After her release, she looked back on her confinement there and said, "The blocks of rock which made up my cell became like precious jewels."

After almost ten years of Jeanne's confinement, things changed. Bossuet relented of his charges. Louis XIV dropped the crown's charges and ordered Jeanne's release. However, the church ruled that she could not be released from prison. The church in Vaugirard had an underground

prison, so Jeanne was transferred from the Bastille to this underground prison. The Bastille had at least been above ground, with small windows.

The Fame of Jeanne Guyon

Bossuet was still on the stage. Once more he began pressuring his fellow archbishop, Fenelon, to sign a statement declaring Jeanne a heretic. If Fenelon did that, Jeanne would be imprisoned forever and possibly hanged or burned! Rather, Fenelon decided to write a book. An archbishop of France writes a book to a fellow archbishop defending a *woman*! First France, then Europe, could not get enough of the duel that ensued.

Imagine this picture: Guyon is in prison. Some want her declared a heretic. An archbishop writes a book defending the woman. Bossuet would not stand for it! Bossuet fired back with a book of his own. Suddenly the nation's two most powerful archbishops were attacking one another in books . . . over a woman. France was turned on its ear.

This little French lady, languishing in prison, was the most talked about woman on the entire continent. England was in sheer glee. In those days, if you could read, you purchased those books, or if not, you had someone read them to you.

Fenelon answered back with book number three. Bossuet wrote the fourth book. No one had ever seen or dreamed of the likes of this! Then came book five and book six.

By now France was euphoric! Now there were not only two archbishops involved, but the king himself became involved. (The king had ordered Jeanne's release, but the church did not comply.) Vincennes, the Bastille, a king, and two archbishops. Could there possibly be more? Jeanne's name was secure in French history.

What did Jeanne think of all this? We will never know. One of the understandings concerning being released from the Bastille was that you would never, as long as you lived, divulge any information about the Bastille. If you did, you would be returned to the Bastille.

One final person entered the fray: the pope himself—Pope Innocent XII. The pope was asked for a judgment on Fenelon's book entitled *The Maxims of the Saints.* Let it be understood that popes were very reluctant to become involved in a controversy. After all, whatever the pope's decision, it would offend a large number of people. Nonetheless, there was an opinion given. One remark was made by the pope:

The Archbishop Fenelon of Cambray erred in loving God too much; Archbishop Bossuet of the diocese of Meaux sinned by loving his fellow man too little.

Fenelon immediately yielded to all charges against him.

That confession came to be known as *The Great Confession* and only further endeared Fenelon to the French.

Jeanne had now been in the three most infamous prisons in Europe for a decade. Archbishop Bossuet finally did something noble. He changed his mind and stated that he felt Jeanne was innocent. This released Guyon from prison. Had it not been for Fenelon's books written in Jeanne's defense, Jeanne would have been forgotten and rotted in a dungeon. That was the fate of Molinos and LaCombe. As it was, Jeanne was now one of the best-known people in Europe, regardless of gender. Jeanne stepped out of prison into a new century on March 24, 1703. Iron gates had finally yielded.

Let the story of this woman's life reach out to you and change your life. It has for so many thousands of other believers. There is no life of any other Christian woman so profound in depth, nor so influential, as that of Jeanne Guyon. Let her devotion melt your heart.

When Jeanne walked out of prison, she was broken in health. It was time for her to slip off the stage and onto the pages of history.

Louis XIV was still on the throne. Madame de Maintenon was still as shrewd, arrogant, and powerful as ever. The warning remained clear: Should Guyon say anything about the Bastille, she would be rearrested and sent back there.

Jeanne went to live in her son's home in a small village just outside of Blois, France. When she arrived, she was a woman rejected by the Roman Catholic Church as a near heretic. But, like it or not, she was adopted by the Protestants. We do not know whether she liked it or not.

Jeanne continued to pick up that awesome pen of hers. Now her books were translated abroad in every language of Europe, as well as in English. John Wesley would later closely follow both her writings and her life[6]. So also were many other men and movements influenced by her . . . until this very day.

Other than Queen Elizabeth, Jeanne Guyon may well have been the most recognized name of any woman in Europe in the 1600s. She was also the most famous person ever placed in the Bastille.

What of today? Though her place in history is secure, still, her life may not yet be fully appreciated!

JEANNE THE AUTHOR

Other than Shakespeare, I know of no writer in either the 1600s or the 1700s whose books sell as faithfully as do those of Jeanne Guyon. Of all the Christian books of the 1600s, I know of only one which is still read as frequently as *Experiencing the Depths of Jesus Christ*. It is *Practicing the Presence of God* by Brother Lawrence.

HER FINAL DAYS

When Jeanne moved into her son's mansion, she had seventeen years left to live. Her notoriety in the English-speaking world, and among all Protestants, had only begun.

HER SCANDINAVIAN FRIENDS

I found the most telling story about Jeanne's final days. As she moved closer toward her death, a group of devout Christian women in Scandinavia took it upon themselves to move to her village. There they set up a vigil around her bed,

[6]Wesley was reported to have once exclaimed, "That woman should have defended herself."

meeting her every need. Those precious ladies sang Jeanne into her coronation day . . . into that realm with which she was quite familiar.

Most books written on the deeper Christian life, as rare as they are, have been written almost exclusively by authors who have been touched by the life and writings of Jeanne Guyon. She was a walking, breathing example of one who walked with her Lord and knew His cross.

If you wish to deepen your spiritual walk with Christ, you must eventually expect to find yourself reading the books of Jeanne Guyon. I recommend the modernized versions of her biography and her autobiography. Add to that, *Experiencing the Depths of Jesus Christ*[7]. Jeanne raises the highest possible standard of one who would dare walk with Christ. She also gives us the highest possible view of one dealing with suffering and a magnificent view and understanding of a daily yielding to the cross. Did anyone ever defend herself so little?

Above all else, see her passion for Christ. She loved Him every day of her life.

As to her influence on my life? She has taught me how to suffer *loss* and do it well. She has taught me to not answer

charges, no matter how false, nor argue, nor ever defend. She has taught me that loss is far better than gain. She has taught me that there is only one centrality, and that centrality is Jesus Christ. She has also taught me to come to Christ without a mind running at full speed.

I have learned that those who love Him most catch the greatest attacks. Devotion to Christ seems to scare legalism the most. Or, to quote the wise words of the great historian Will Durant:

> *The church has persecuted only two kinds of*
> *people: those who do not believe the teaching*
> *of Jesus Christ and those who do.*

If you have an inclination to attack another Christian, I would encourage you, before you do, to read the life of Jeanne Guyon.

Biographies which have been written on the lives of Christians who have suffered and lived a sacrificial life usually seem to pale in comparison to the lifelong journey which Jeanne Guyon so magnificently endured.

Now we come to the unexpected.

[7]SeedSowers Publishing House

My sojourn into the life of Jeanne Guyon should have ended with her death. It did not. I decided to find out where she was buried. That may have been a mistake.

From this moment on, I warn you, dear reader, prepare to be stunned.

I followed Jeanne Guyon's path across France and Switzerland, finally to discover what had happened to Jeanne Guyon after her death. What I discovered was implausible; yet, it somehow seemed to match her life: well-known, unknown . . . famous, forgotten . . . forever being rediscovered.

Jeanne was buried inside the largest church in Blois, France. Since then the church has been torn down. During the French Revolution, France turned against the Roman Catholic Church and became an agnostic, atheist nation. Many churches were torn down.

I went to the site of the church building which had once held Jeanne Guyon's body. The church was no longer there. In its place was the inevitable school.

After the church was torn down, what happened to Jeanne Guyon's body? Prepare for the *first* shock! Her body was thrown into a river.

Shock number two: Jeanne Guyon's body was retrieved but it was headless! Her skull was not there.

I remembered that her body had an autopsy done on it. Was there a connection? I recall the doctor's words about the autopsy: "There were only two things about Jeanne Guyon's body that were in good health. One was her brain; the other was her heart. Those are the two things by which she so beautifully lived."

Was it possible that the doctor had kept the head of Jeanne Guyon? Again, never underestimate the staying power of that little French lady. Yes, that is exactly what happened. The doctor had kept the head of Jeanne Guyon.

Her skull was taken to the largest museum in the city of Orleans[8]. I was in a quandary. Did I dare even ask if it had survived? Dare I go to Orleans? What would I do? Of one thing I was certain: If it still existed, *I did not want to see it.*

I made my way to the Orleans museum and to the curator. He immediately recognized Jeanne's name. He

knew the story of her life, and he knew about her skull. He even handed me a pamphlet with a photo of her skull on the cover. The pamphlet itself was close to a hundred years old. I asked for an additional copy. There was none.

There it was, printed on the front page of the pamphlet: The Skull of Jeanne Guyon!

The curator then stepped out of the room. A moment later, he returned. His report: No, the skull of Jeanne Guyon no longer existed. Here was the story: At the very outset of World War II in 1939, the Italian Air Force bombed Orleans, France. A stray bomb hit and destroyed one wing of the museum. The skull of Jeanne Guyon was destroyed along with that part of the museum.

I sat back in the chair, only to have a most interesting thought. Whenever the Roman Catholic Church decides to investigate the life of someone being considered for sainthood, one of the things the scholars look for is the possibility of a *miraculous* preservation of that saint's body. Jeanne Guyon had come within a hair's breadth of that condition. (In my Protestant opinion, Jeanne Guyon should be sainted by the Roman Catholic Church.) It would seem that the miraculous

[8]The city of New Orleans, Louisiana was named after a city in France named Orleans.

preservation of Jeanne's body might play a part in her being sainted by the church, but in the enigma of Jeanne's life, that miraculous preservation was also destroyed when her skull was destroyed. One of the conditions for her sainthood had first come and later had gone.

Once more, it is impossible to escape the irony that has followed her life . . . even *after* her death. Jeanne did not quite make it into acceptance in her church, but she did among Protestants.

I visited the mansion where Jeanne Guyon died. I met a young couple there who drove back and forth to Paris every day so they could live in Jeanne's home.

HER CONTRIBUTION

Jeanne remained in the Roman Catholic Church, yet she was in every way a Nonconformist. Some of her writings have survived.

What men and movements did Guyon influence? She almost authored the Quaker movement; she greatly influenced the Moravians, John Wesley and the entire Wesleyan movement, as well as Hudson Taylor and Watchman Nee and the Little Flock of China. The Quaker movement is not only indebted to the writings of Jeanne

Guyon, but they used her writings as their textbooks. In fact, when it comes to allowing us to see one's relationship to the cross and to Christ, I do not know another biography to recommend. Beyond that, there have been so many well-known and devout Christians who have recommended her writings, they are innumerable.

I would ask the "keepers of the flame," those who are ready to draw a sword on anyone who disagrees with them, to read this woman's life. She is a living example of brokenness. If you hope to understand the cross, read Guyon. The book, *Experiencing the Depths of Jesus Christ* has been translated into a dozen languages, including the French version—translated out of English into French!

I have encouraged both the autobiography and the biography of Jeanne Guyon to be issued in modern English. I repeat: There is no other book I can recommend to this age on the life of a Christian who gives us a glimpse of what brokenness means.

I will close with a sentence I found in the worn-out copy of *A Short and Simple Method of Prayer,* which later came to be known as *Experiencing the Depths of Jesus Christ.*

On the opening page was the following statement:

The fact that you now hold this book
in your hand means that God wants
to do a special work in your life.

I can close with no better tribute to this amazing woman.

Epilogue

On rare occasions, you may come across a criticism of Jeanne Guyon. I suppose one could find a fairly good reason to criticize any Christian, but I would ask an assailant who is about to do that, "Does your daily living measure up to Jeanne Guyon?"

Criticism concerning Jeanne Guyon usually comes down to: "Jeanne Guyon does not quote enough Scripture." She quoted more scripture than most of us will ever do.

Jeanne Guyon was the first person in history ever to write a commentary on every book of the Bible.

Also note this: She probably uttered the name *Jesus* . . . and with so much love and passion . . . more than any of us.

Then there is something else—Jeanne's predilection to get into trouble. I have often mused, "Jeanne Guyon could jaywalk and end up in prison for doing so. Everything she did resulted in extreme criticism, even to the constant drumbeat of, "You are a heretic. You will be burned at the stake." Some who call themselves the faithful do not like people who love Jesus excessively.

Then there is the question for all of us: Could you bear ten years in a 1600s French prison with little light and often in total darkness? How would you hold up to hearing that you were the most maligned, hated woman in France? How would you deal with a band of clergy who have already decided that you are an ignorant, *woman* heretic? How would you handle being badgered by clergymen about theology for hours on end? In the one year when she was in Vincennes, she faced eighty bombastic inquisitions lasting from ten to twelve hours per day. Her writings reflect none of this.

The number of pages Jeanne Guyon wrote in her lifetime numbered in the thousands. Beyond that, every single word she wrote was first written by hand. Then those words were typeset by hand, with each page of every book printed *one* page at a time.

In all of this, Jeanne never lost her humor nor her dignity. In a world troubled by famine and plagues, she managed to live to be seventy, an age rarely reached by women of that day.

Jeanne's life matched her professions. To you who might write a criticism, I do hope your books will still be in print—

and popular—one hundred years from now. I also hope you will have at least four biographies written about you.

There is one thing which is certain: Christians will still be reading Jeanne's books three hundred years from now. Those books give solace and spiritual depth to all who read her.

Then there is the enigma and irony of her life.

I was in Quebec City (French Canada) and saw on the city directory a street named after Jeanne. I drove out to the site feeling, "So Jeanne will be remembered in one place— the New World."

I failed to take into account the way God and history have dealt with Jeanne. Arriving there, I found *no* Jeanne Guyon Street. In its place was a large housing complex which had entirely swallowed up the street named after her.

On the other hand, a hundred or two hundred years from now, that complex will be torn down. If I know anything about this little lady's life, someone will remember there was once a street there named *Jeanne Guyon.* She will *still* be famous. The street will once more bear the title rue Jeanne Guyon!

As they say in French, "Vive. Vive Jeanne Guyon! Vive!"

Yes, Jeanne, one day you will be included in the history of the nonconformists. Furthermore, you will have the right to be numbered among that illustrious band.

Eugéne Edoir
(Gene Edwards)

Books by Jeanne Guyon

Experiencing the Depths of Jesus Christ

Spiritual Classics by Jeanne Guyon

Song of Songs
Intimacy with Christ
Final Steps in Christian Maturity
Spiritual Torrents

Commentaries by Jeanne Guyon

Genesis
Exodus
Leviticus
Numbers
Deuteronomy

I, Jeanne Guyon
by Nancy James PhD

The newest and best book on the life of Jeanne Guyon. It is a combination of both her autobiography and biography written in first person.

Other books by Gene Edwards

A Tale of Three Kings
Divine Romance
The Prisoner in the Third Cell
100 Days in the Secret Place
Living Close to God When You're Not Good At It
Passport to the First Century (2015)

The First Century Diaries:
The Silas Diary
The Titus Diary
The Timothy Diary
The Priscilla Diary
The Gaius Diary

The Chronicles of Heaven:
The Beginning
The Escape
The Birth
The Triumph
The Return

Contact **SeedSowers Publishing House** for other books by Gene Edwards. Or go directly to our website and view the catalog online at www.seedsowers.com.

SeedSowers
Christian Books Publishing House
PO Box 3317
Jacksonville, FL 32206
1-800-228-2665
www.seedsowers.com

I, Jeanne Guyon

by Nancy C James, Ph.D.

This is the story of one who became the most known woman in Europe during her lifetime. Here is the story of her imprisonments more vivid than ever before. *I, Jeanne Guyon* will now spread the incredible story of her life even farther and cause it to be even more influential.

Now Nancy James has given us a new, better, and clearer story of Guyon's life. Dr. James has combined Guyon's biography and autobiography into one. The author has then cast the story in first person, that is, with Guyon speaking. Dr. James has added fresh, new insight into the life of church history's most revered and influential woman.

Jeanne Guyon has influenced the lives of hundreds of thousands of Christians. That includes Adoniram Judson, Hudson Taylor, the Quakers, John Wesley and the Methodists, Watchman Nee and the Little Flock, and just about everyone who has ever read her life story. Beyond that, *Experiencing the Depths of Jesus Christ*, which has never been out of print in three hundred years since it was written, is to be found on the list of the ten most recommended books for a Christian to read.

SeedSowers

Christian Books Publishing House
PO Box 3317 ● 4003 N. Liberty St.
Jacksonville, FL 32206
www.SeedSowers.com

1-800- ACT BOO
1-800-228-2665

NEW

I, Jeanne Guyon	*James*
The Jeanne Guyon Nobody Knows	*Edwards*
Here's How to Win Souls	*Edwards*

INTRODUCTION TO THE DEEPER CHRISTIAN LIFE

Living by the Highest Life	*Edwards*
Secret to the Christian Life	*Edwards*
Inward Journey	*Edwards*

SPIRITUAL CLASSICS

Experiencing the Depths of Jesus Christ	*Guyon*
Practicing His Presence	*Lawrence/Laubach*
Spiritual Guide	*Molinos*
The Seeking Heart	*Fenelon*
Intimacy with Christ	*Guyon*
Song of Songs	*Guyon*
Final Steps in Christian Maturity	*Guyon*
Spiritual Torrents	*Guyon*

THREE CLASSICS BY ONE AUTHOR

A Tale of Three Kings	*Edwards*
The Divine Romance	*Edwards*
Prisoner in the Third Cell	*Edwards*

THE CHRONICLES OF HEAVEN

The Beginning	*Edwards*
The Escape	*Edwards*
The Birth	*Edwards*
The Triumph	*Edwards*
The Return	*Edwards*

THE FIRST-CENTURY DIARIES

The Silas Diary	*Edwards*
The Titus Diary	*Edwards*
The Timothy Diary	*Edwards*
The Priscilla Diary	*Edwards*
The Gaius Diary	*Edwards*

Christian Walk

Living Close to God (When You're Not Good at It)	*Edwards*
100 Days in the Secret Place	*Edwards*
Adoration	*Kilpatrick*

COMFORT AND HEALING

Healing for Christians Who Have Been Crucified by Christians	Edwards
Letters to a Devastated Christian	Edwards
Dear Lillian	Edwards
Suffering	Pradhan

BOOKS ON CHURCH LIFE

Climb the Highest Mountain	Edwards
How to Meet in Homes	Edwards
The Organic Church vs the "New Testament Church"	Edwards

OLD TESTAMENT

Guyon's Commentaries	Guyon
Genesis • Exodus • Leviticus-Numbers-Deuteronomy	
Judges • Jeremiah	

NEW TESTAMENT

Christ Before Creation	Edwards
Story of My Life, as Told by Jesus Christ	The Gospels
Your Lord Is a Blue Collar Worker	Edwards
The Day I Was Crucified	
Revolution, The Story of the Early Church	Edwards
Revolutionary Bible Study	*Edwards*
Unleashing the Word of God – with a DVD	*Edwards*

CHURCH HISTORY

Torch of the Testimony	Kennedy
Going to Church in the First Century	Banks
Passing of the Torch	Chen

BIOGRAPHIES

I, Jeanne Guyon James
The Jeanne Guyon Nobody Knows Edwards
The Life of Jeanne Guyon Upham

BOOKS BY JOHN SAUNDERS

Modern Parables - the collection Saunders

Individual books available

The Tiger Is Dead ● House of God ● Tabernacle of David
● Guardians of the Ark ● God of Preparation ● Heart
for the Stretch
□ Remnant for the House ● Kings unto God

EVANGELISM

Here's How to Win Souls Edwards
You Can Witness with Confidence Rinker

RADICAL LITERATURE

How Paul Trained Men Edwards
Are We Really Being Biblical? Edwards
God Is Looking for a Man for the 21st Century Edwards

Experiencing the Depths of Jesus Christ

by Jeanne Guyon

The most loved book on the Deeper Christian Life. One of the most read Christian books in all church history. Giving the reader more help than is found in any Christian literature on knowing Christ: both profound depth AND practical help.

This book has affected hundreds of thousands of lives. It has never been out of print in 300 years and is the most read book penned by the best known Christian woman writer: Jeanne Guyon.

The #1 book on the Deeper Christian Life for 300 years!

CPSIA information can be obtained at www.ICGtesting.com
Printed in the USA
LVOW12s2339180615

442854LV00001B/3/P